# THE LIFE AND WORKS OF

# LAUTREC

Nathaniel Harris

A Compilation of Works from the
BRIDGEMAN ART LIBRARY

PARRAGON

**Lautrec**

This edition first published in Great Britain in 1994
by Parragon Book Service Limited

© 1994 Parragon Book Service Limited

ISBN  1 85813 531 1

Printed in Italy

Designer: Robert Mathias

# HENRI DE TOULOUSE-LAUTREC   1864-1901

*Lautrec*

HENRI DE TOULOUSE-LAUTREC was an aristocrat, an alcoholic bohemian, and a great artist. Afflicted with sad physical disabilities, he discovered a milieu which distracted and amused him, and became its most vivid chronicler. The pleasures and vices of Parisian night-life, its celebrated performers and forgotten street girls, live for ever in Lautrec's work. As well as being a painter, he was a great popular artist, pioneering the bold and blatant new medium of the poster. A prodigious worker, he simultaneously pursued a self-destructive life-style that killed him at the age of thirty-six.

Henri Marie Raymond de Toulouse-Lautrec Montfa was born on 24 November 1864, at Albi in south-west France. His family was ancient, distinguished and wealthy; unlike many other great artists, Lautrec never had serious money worries, except when his erratic behaviour provoked threats to cut off his generous allowance.

The negative side of Lautrec's ancestry was the inbreeding that had gone on over generations, culminating in the marriage of his father and mother, who were first cousins. As a result, Lautrec almost certainly suffered from a degenerative bone condition which was responsible for two accidents in 1878-79, when he broke both thigh bones in seemingly harmless falls. The bones took a long time to mend, and it eventually became

apparent that the teenage boy's legs were not growing properly. Lautrec was condemned to become a small, grossly disproportioned man, stumping about in ungainly fashion with a stick – a figure he would often caricature in his drawings, typically using self-mockery to ward off self-pity.

Lautrec's family encouraged his boyhood passion for drawing, but he would probably have remained a gifted amateur if his disabilities had not cut him off from the sporting and social round of the aristocracy. As it was, Lautrec's parents put up little resistance when he announced his wish to become a painter – though they can hardly have anticipated the kind of painter he would turn out to be.

In 1882 Lautrec went to Paris as a student, at first working under conventionally successful masters while he ceaselessly drew and painted portraits. By his mid-twenties he had developed his own personal style, based on his superb gift as a draughtsman: the line, swift, incisive and telling, became Lautrec's hallmark, whatever the medium in which he happened to work.

By this time he had also found his most celebrated subject – Montmartre, not so long before a village, but now an increasingly gaudy, pleasure-oriented district on the northern edge of Paris. In his first unmistakably great works, Lautrec recorded the life of the circus, the dance-hall, the cabaret and the music hall, some of whose stars he portrayed again and again. The seamier side of Parisian nights drew him too, and he even moved into *maisons closes* (brothels) for long periods, portraying their inhabitants in an unenchanted, matter-of-fact manner that is anything but pornographic.

The greatest attraction of Montmartre was the Moulin Rouge, where dancers like La Goulue gave frenzied performances of the quadrille, later renamed the can-can. It was for the Moulin Rouge that Lautrec made his first (and still most famous) poster, using the relatively new lithographic process. By contrast with older techniques such as engraving, lithography enabled the artist to draw fluently straight on to a stone from which the printing was done. Lautrec understood at once that bold lines and strong flat colours were what was needed to make an effect and catch the eye of the passer-by; and his are the first classic posters.

Meanwhile, he steadily destroyed himself. By 1897, syphilis and alcoholism were affecting his behaviour, and in 1899 he was 'dried out' in a sanatorium. But he soon relapsed into hard drinking, despite a series of paralytic fits. After a final stroke he was taken to his mother's home, where he died on 9 September 1901.

*Detail*

▷ **Self-portrait 1880**

Oil on wood

PAINTED WHEN LAUTREC was about sixteen, this sombre, introspective self-portrait is unique among his works; in future, whenever he drew or painted himself, it would always be as an incidental figure in a scene or else as a caricature, with his physical disadvantages emphasized as a form of mocking self-defence. Here, for once, Lautrec confronts himself, and the result is unsettling. Like many artists, he has painted a mirror image of himself, built up in dark tones with broad, seemingly swift brushstrokes.

The composition shows only the upper part of his body, concealing the legs which had been stunted by the effects of his accidents two years before. In fact there is a strong suggestion that the artist has taken refuge behind the miscellaneous objects on the mantelpiece in front of him. His face is in shadow, and the circular smudges of paint that suggest his pince-nez (spectacles without sidepieces, very common at this period) veil his expression, leaving it enigmatic in spite of the directness of his gaze.

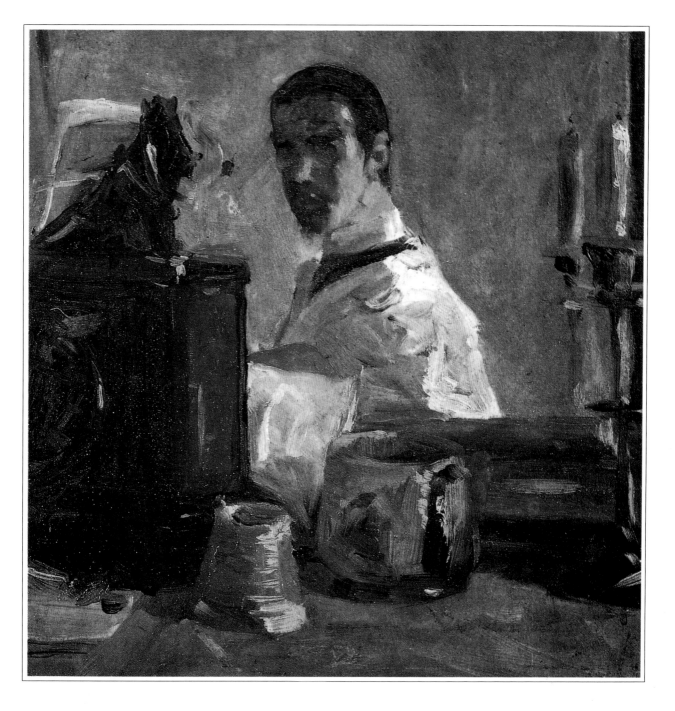

▷ **Count Alphonse de Toulouse-Lautrec
Driving his Mail Coach** 1880

Oil on canvas

THOUGH VERY DIFFERENT from the subjects for which Lautrec became famous, this is a spirited early work. For a few years in his teens, even after he could no longer ride, Lautrec loved horses, and the steeds in this picture are shown as strong and fast, pounding their way through clouds of dust. The commanding figure of the driver is Lautrec's father, Count Alphonse. The Count was a dedicated horseman and hunter, a compulsive womanizer, and eccentric in the extreme. Lautrec also painted him on horseback with a falcon, and dressed as a Circassian – one of several exotic costumes which he adopted when the fancy took him, even on the streets of Paris. Count Alphonse showed only a fitful interest in his ailing son, but he did have artistic inclinations and actually introduced the young Henri to the artist René Princeteau, who became his first teacher.

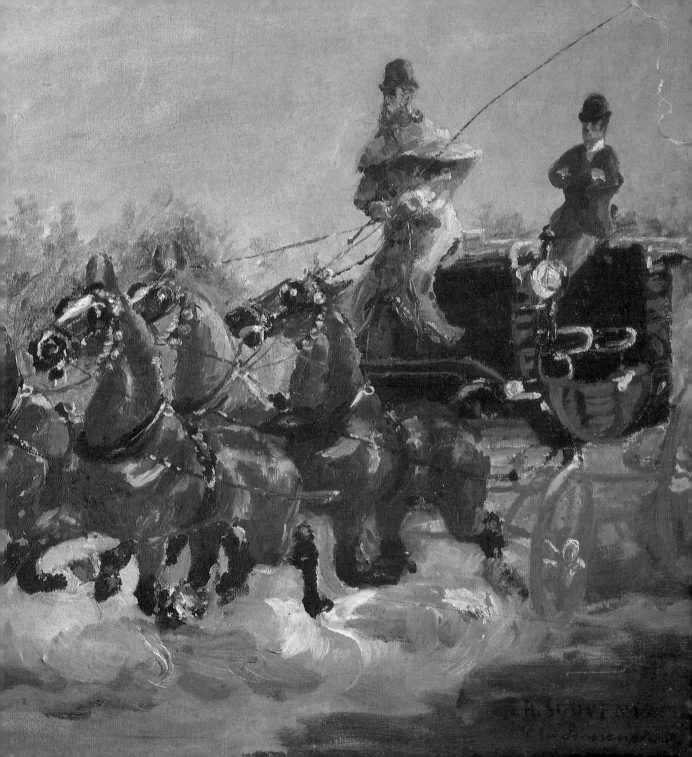

▷ **Portrait of the
Artist's Mother** 1881

Oil on canvas

DURING THE 1880s Lautrec
painted a number of portraits
of his mother. This one shows
her having breakfast at
Malromé, her home in the
south-west. Though Lautrec
has not yet found his
characteristic manner, it is a
pleasingly tender work,
evoking his mother's quiet,
long-suffering personality.
After the death of a second son
in 1867, the Count and
Countess lived virtually
separate lives, and the
Countess devoted herself to
her surviving child, Henri.
Behind their aristocratic
formality, Lautrec's letters
suggest a deep affection for his
mother and a degree of
emotional dependence on her.
For years she lived in Paris in
order to be close to him,
although eventually his
alcoholic deterioration became
too much for her to bear and
she fled back to Malromé.
When Lautrec's final illness
began, he was taken back to
Malromé to die.

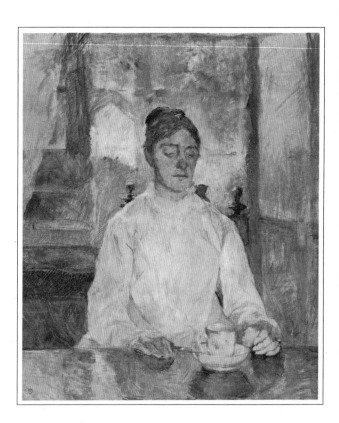

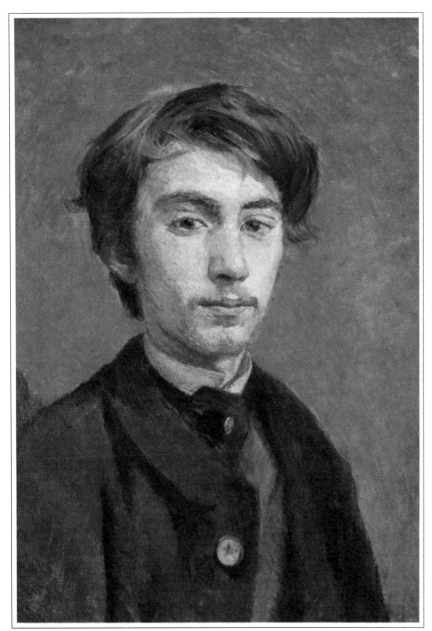

◁ **Portrait of Emile Bernard** 1886

Oil on canvas

EMILE BERNARD was Lautrec's friend and fellow-student during the early 1880s, when both young men were working under the history painter Fernand Cormon. This is a fairly conventional but touching portrait of a sensitive young artist at the outset of his career; in his memoirs, Bernard claimed that he had had to endure 20 sittings before Lautrec was satisfied. Unlike Lautrec, Bernard was a passionate theorist, possibly to the detriment of his art; he is now better known for his influence on painters such as Gauguin than for his own work. Lautrec and Bernard were part of a group of rebellious young students at Cormon's, joined in 1886 by a strange, intense Dutchman who was already in his thirties. This was Vincent van Gogh, captured in a perceptive pastel drawing made by Lautrec at the time.

▷ **Portrait of Suzanne Valadon**  1886

Oil on canvas

BY CONTRAST WITH THE *Portrait of Emile Bernard,* painted only a year before, this shows some of the characteristics of Lautrec's mature style, especially in his use of trailing and criss-crossed ('cross-hatched') lines. The sitter looks a solemn, rather pensive young woman, sitting very still for fear that her tall fancy hat might fall off. But here appearances are deceptive. She is Suzanne (originally Marie Clementine) Valadon, a woman of powerful, untamed personality. A circus acrobat until a fall cut short her career, she took up modelling for Degas, Renoir and other artists. Lautrec met her in 1885 when she was still only eighteen, and the two became lovers. The affair lasted, on and off, until 1888. Lautrec is said to have broken it off after discovering that Valadon had faked a suicide attempt in the hope of making him marry her. Remarkably, she went on to make an independent career as an artist of real stature.

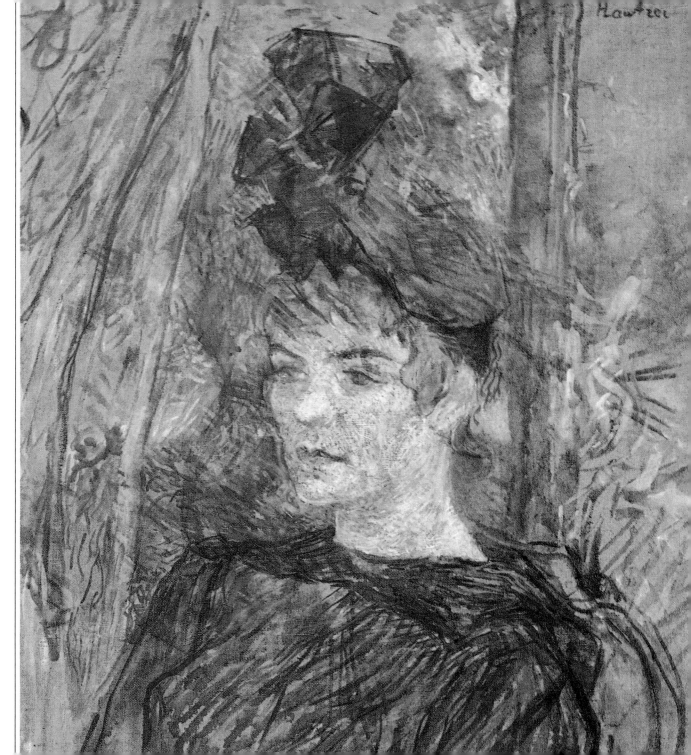

*Detail*

▷ **Portrait of Emile Davoust** 1889

Paint on cardboard

FOR LAUTREC, this is unusual in both subject and treatment. He did enjoy life by the sea, spending his summers with a friend at Taussat, a little resort not far from Bordeaux where he went swimming and sailing. But as an artist he took the people, pleasures and vices of the town as his subject, and once his apprenticeship was over he rarely strayed from it. Here, however, the sense of open-air freshness and the melting, watery quality of the background are reminiscent of an Impressionist painting by an artist such as Claude Monet. However, there is nothing Impressionist about the solidity with which the boat is rendered, the strong near-diagonals that give the composition its firm structure, or the Lautrecian cross-hatching of the seaman's jersey. The pipe-smoking mariner, stolid yet not quite at ease, owned the boat, *Le Cocorico* (Cock-a-doodle-do!), which Lautrec had hired for that season.

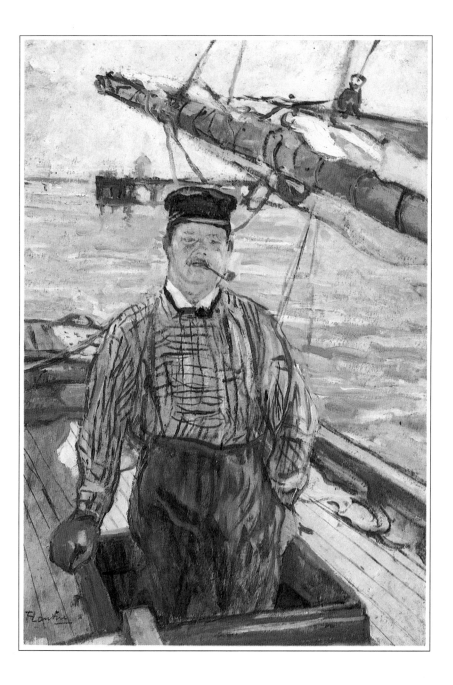

▷ **Dance at the Moulin de la Galette** 1889

Oil on canvas

BY 1889 LAUTREC was launched on his career as a 'painter of modern life'. He was making studies of the circus and also of the Moulin de la Galette, the first of the Montmartre dance halls he frequented, often sketching quietly in a corner seat. The Moulin de la Galette belonged to the older, working-class Monmartre, before the area became a fashionable haunt of pleasure-seekers. Pierre Auguste Renoir had painted dancing in the establishment's garden as long before as 1876. Typically, Lautrec chose an indoor setting for this, one of his earliest multi-figure works. The scene effectively contrasts the immobile boredom of the 'wallflowers' in the foreground with the swaying figures of the dancers. The man in the bowler is Lautrec's fellow-artist, Joseph Albert, the first owner of the painting. The pile of saucers, seemingly swaying to the music, is a nice touch; in reality, waiters did leave a saucer behind every time they removed a glass, so keeping a tally of the number of drinks served.

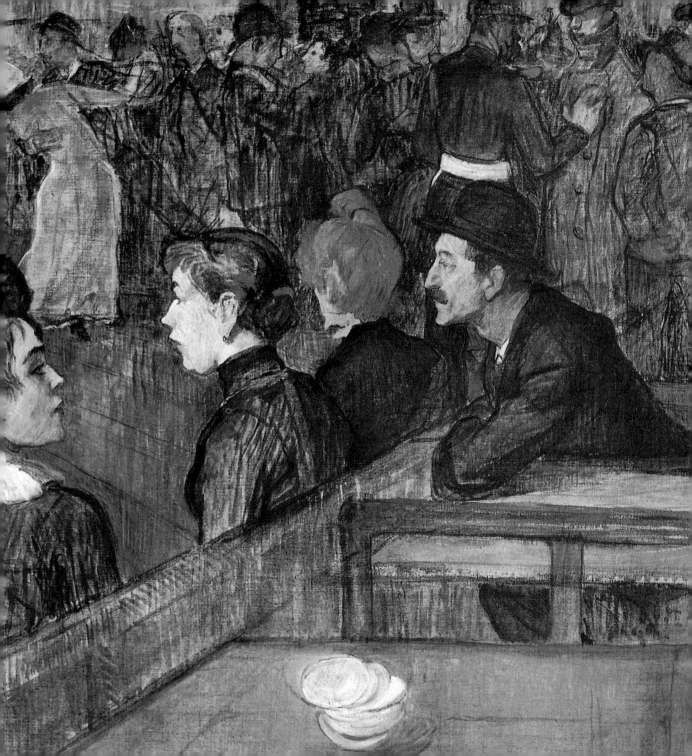

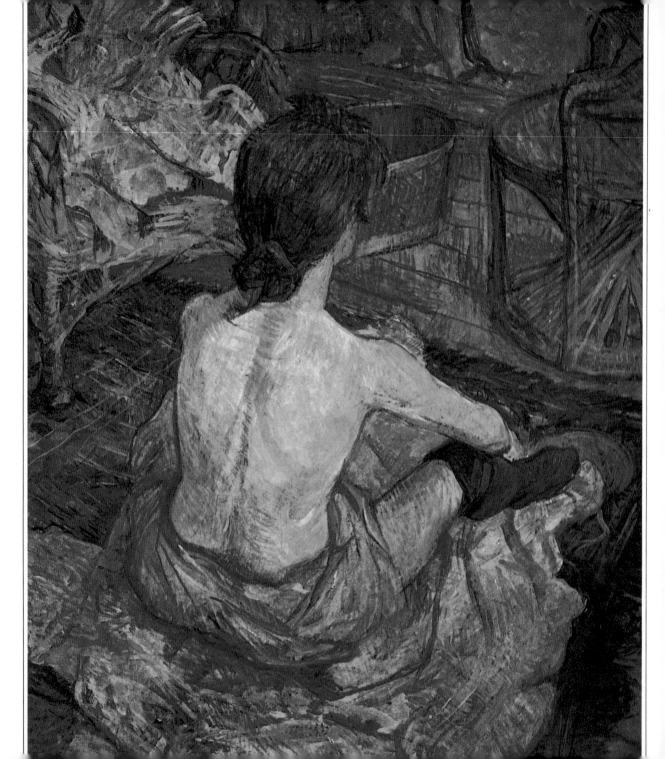

◁ **Woman at her Toilet** 1889

Paint on cardboard

IN THE PAST this has usually been dated 1896, but new evidence suggests the much earlier date of 1889. The issue is complicated by the fact that the style is not entirely typical of Lautrec. The picture may have been painted in response to exhibitions of nudes by Edgar Degas, the living artist whom Lautrec most admired. It is particularly strongly drawn and finished, with something of Degas' 'looking-through-a-keyhole' quality; the absence of a single face in the composition also makes it a rarity in Lautrec's output. On the other hand, the matter-of-fact, slightly awkward posture is a Lautrec trademark. By contrast with Degas, who passed for a misogynist but created marvellously carnal visions of female flesh, the brothel-haunting Lautrec is deliberately unsensuous, disenchanted in his depiction of his models' bodies. Whether Degas-inspired or otherwise, this is among his finest works.

▷ **Dance at the Moulin Rouge** 1890

Oil on canvas

ONCE THE MOULIN ROUGE opened in 1889, Lautrec lost interest in the Moulin de la Galette (page 18), seduced by the more hectic atmosphere and greater social mix of the new dance-hall. The change is virtually signalled by the brighter colours of this painting and the furred and feathered costume of the lady in the foreground; but the simplest indicator of the class difference is the higher percentage of top hats at the Moulin Rouge. Lautrec was mainly concerned with people, indicating the setting sketchily unless it was an intimate one; but here, at least, we have a sense of the size and gas-lit ambience of the famed Moulin Rouge. However, Lautrec uses one of his favourite devices to direct our attention, employing large foreground figures to frame the 'action', a lively dancing partnership. The Moulin Rouge became one of his great subjects, inspiring some thirty paintings, lithographs and the most famous of all his posters (page 27).

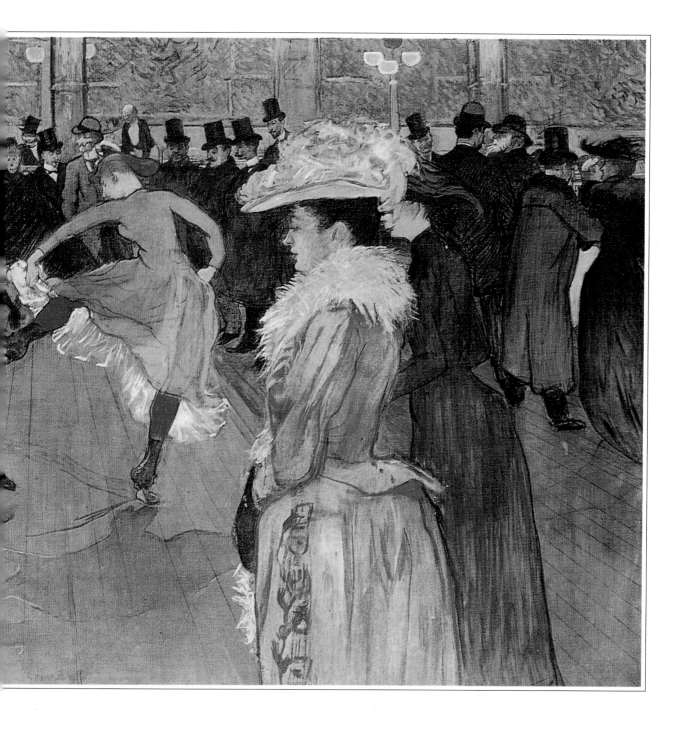

▷ **Portrait of Justine Dieuhl** c.1890

Paint on cardboard

PARALLEL WITH HIS more celebrated studies of night life, Lautrec painted a series of outdoor portraits of young women in the early 1890s. They are all unknowns, possibly picked up by the artist in the street or backstage. Whereas most of Lautrec's models of this type look fairly well fed and self-possessed, Justine Dieuhl is gawky and narrow-shouldered and seems very young. She wears a basic version of the elaborate headgear and formal dress of the period: the portrait of the luxuriously dressed Honorine P. (page 25) reveals the gulf that existed between the classes. Justine's solemn, 'sitting-up-straight' pose also identifies her as a working girl on her best behaviour. One of the most striking features of the portrait are Justine's hands: large, work-roughened, and clumsy even in repose.

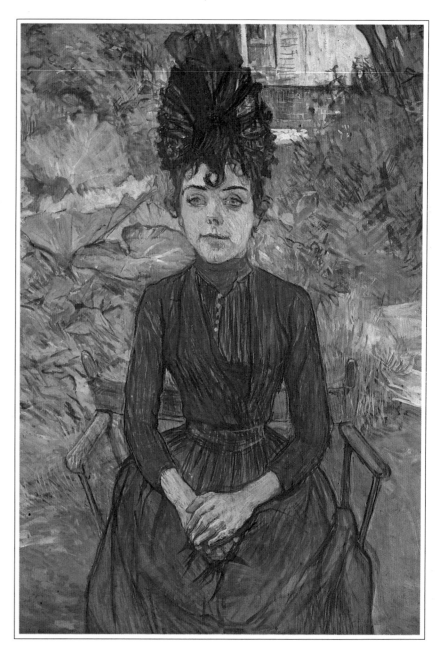

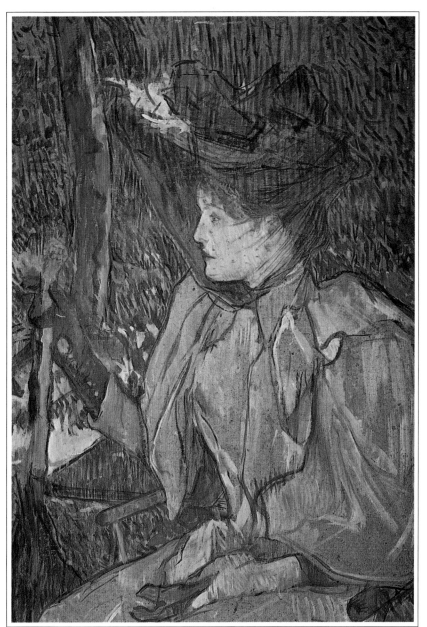

◁ **Portrait of Honorine P.** c.1890

Paint on cardboard

THIS PORTRAIT IS ALSO KNOWN as *The Woman with Gloves,* a title no doubt suggested by the way that Honorine's rich red, multi-buttoned right glove catches the eye. The painting is one of a series of outdoor portraits of obscure young women, and although we know that Honorine P. was actually Honorine Platzer, that is all we do know about her. What makes this surprising is that she seems to come from a much higher class than Justine Dieuhl (page 24). It is possible, but unlikely, that Lautrec dressed up the model for the occasion; at any rate, her veil, cape, gloves and parasol are all signs of genteel affluence. Lautrec shows her, with evident intent to flatter, in profile. His long brushstrokes, and the large areas of unpainted card in the woman's dress, typify his technique in this medium.

## ▷ **Portrait of Henri Dihau** 1891

Paint on cardboard

ANOTHER OF LAUTREC's garden portraits, this time of a gentleman in late middle age. Like the portraits of the young women (pages 24 and 25), it was painted in the leafy, overrun garden of a retired businessman known as Père Forest. As always, Lautrec's interest was concentrated on the human element, and the garden itself is rarely more than a charming setting and compositional aid; here the verticals frame and give the impression of greater height to the rather stubby figure of Dihau. Henri Dihau, his brother Désiré and his sister Marie were distant relatives of Lautrec's. Despite their Montmartre address, they were respectable elderly musicians (Désiré was a bassoonist in the orchestra of the Paris Opéra). Lautrec painted portraits of all three Dihaus about this time.

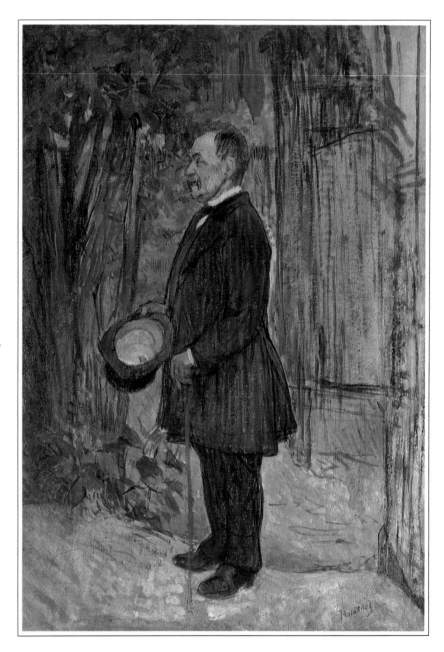

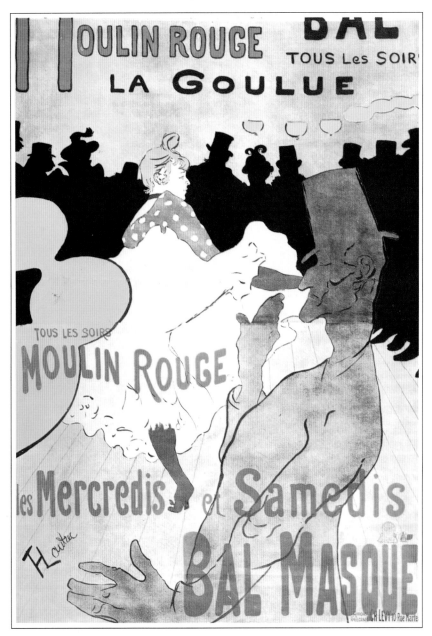

◁ **Moulin Rouge –
La Goulue** 1891

Poster

THIS WAS LAUTREC'S FIRST poster, commissioned by the owners of the Moulin Rouge, which had opened in 1889. It was the grandest, gaudiest place of entertainment in Montmartre, combining the attractions of dance-hall and music hall with a pleasure garden. For years this was to be Lautrec's favourite night-spot, inspiring countless pictures of its performers and customers. Easily the most famous of the dancers was Louise Weber, nicknamed La Goulue (the Glutton), whose high kick and brilliant, frothing underwear are the focus of Lautrec's poster. In the foreground is another well-known Moulin Rouge character, Valentin le Désossé (Valentin the Boneless). In this celebrated work Lautrec has already discovered the importance of bold outlines and the elimination of detail (the audience, for example, becomes a frieze-like silhouette) in the art of the poster.

## ▷ **Two Women Waltzing**  1892

Paint on cardboard

ANOTHER SCENE at the dance-hall of the Moulin Rouge. Two women are dancing; a third is leaving the floor; beyond them, behind the barrier that divides the picture horizontally, other customers sit at tables while a waiter hurries round serving them. Lautrec was fascinated to the point of obsession with lesbianism, and there can be little doubt about the inclinations of the dancing partners. Lautrec's account of them is unsensational, indicating their intimacy by the way in which they hold each other and their expressions; interestingly, they are the only people in the picture who look happy. As he often did, Lautrec persuaded friends to model for him. The bearded man on the left is the French painter François Gauzi; the man on the far right is the Australian artist Charles Conder, in his way as much a self-doomed figure of the 90s as Lautrec. Jane Avril is the woman in the red blouse; the woman dancing with closed eyes is the celebrated Clowness (page 58).

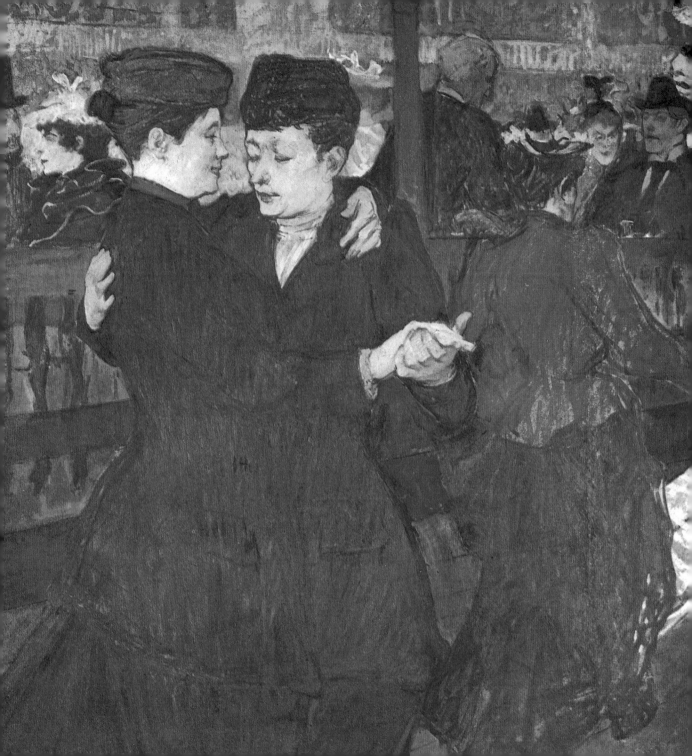

▷ **The Englishman at the Moulin Rouge** 1892

Lithograph

ONE OF THE MANY habitués of the Moulin Rouge who caught Lautrec's observant eye was William Tom Warrener, a Lincolnshire man about town and minor painter. To judge from Lautrec's portraits of him, Warrener had the keen but cooly self-possessed air that the French thought of as typically English. Evidently fascinated, Lautrec made a number of studies and a painting of *The Englishman at the Moulin Rouge*. But this is the most celebrated version of all, deriving its distinctive look from the fact that it is a print, executed in the same lithographic medium as Lautrec's posters. Putting the Englishman's figure in shadow-like silhouette was a brilliant inspiration, enriching the colour scheme and separating the two sides in the war of the sexes. Lautrec also added piquancy to the scene by making Warrener – actually a young man – look like an elderly rake.

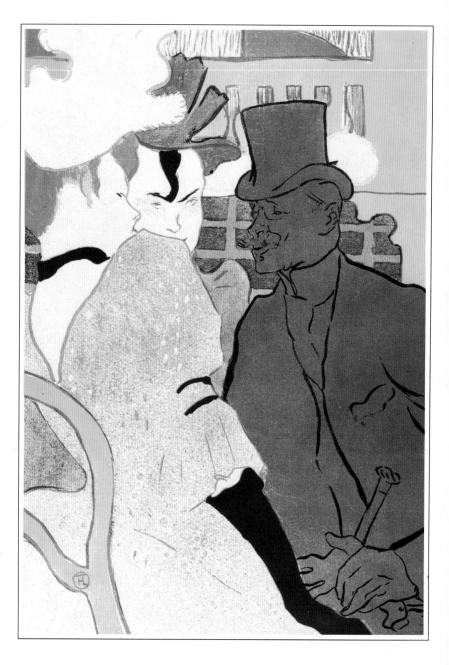

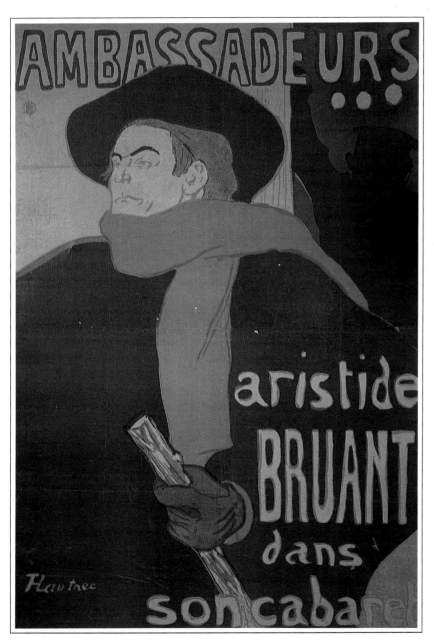

◁ **Aristide Bruant at Les Ambassadeurs** 1892

Poster

LAUTREC'S SECOND POSTER featured Aristide Bruant, a cabaret artist who shot to fame by cleverly exploiting the decadent mood of the 90s. His songs were about the life of the streets, poverty, sex and crime. He commissioned this poster from Lautrec, and when the manager of Les Ambassadeurs refused to use it, Bruant forced him to yield by threatening to cancel his engagement. In the event, it was put up all over Paris. Bruant was perceptive enough to realize that Lautrec was revolutionizing poster art: even more than in *Moulin Rouge – La Goulue* (page 27), the simplified forms, bold outlines and flat colours were startlingly effective in catching the attention of the passer-by and putting over the message. Lautrec produced three more posters for Bruant, making both his own and his client's reputation.

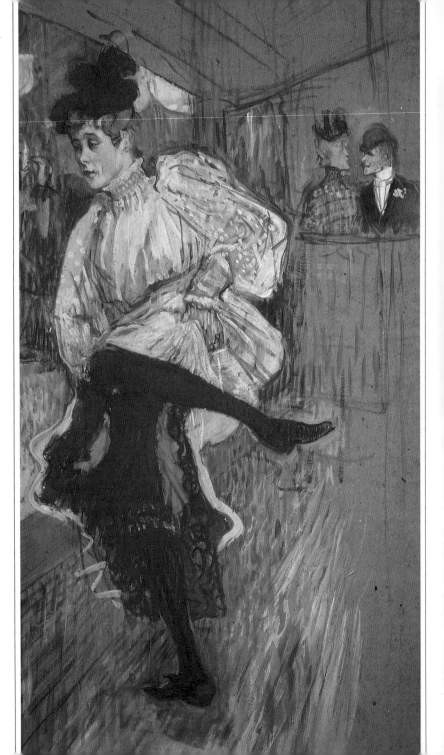

▷ **Jane Avril Dancing** 1892

Paint on cardboard

THIS IS ONE OF LAUTREC'S most
delightful paintings, filled with
unusual tenderness despite the
music-hall subject. Jane Avril
was a young dancer who
began her career at the Moulin
Rouge in 1889 and quickly
became a star; Lautrec, who
was fascinated by her, is said to
have actively promoted her
career. Her speciality as a
dancer was the step we can see
here, which involved locking
her arms around one thigh
and flourishing her long, thin
legs, evidently to considerable
artistic or erotic effect. But her
greatest appeal lay in her
remote, seemingly refined
personality; Lautrec captures
her self-absorption here and in
two other paintings. Audiences
nevertheless nicknamed her
*La Mélinite* (Dynamite). The
only visible spectators in the
picture are a man and his lady
friend; the man is surely
Lautrec's friend Warrener
(page 30), sporting a curly-
brimmed bowler instead of a
top hat.

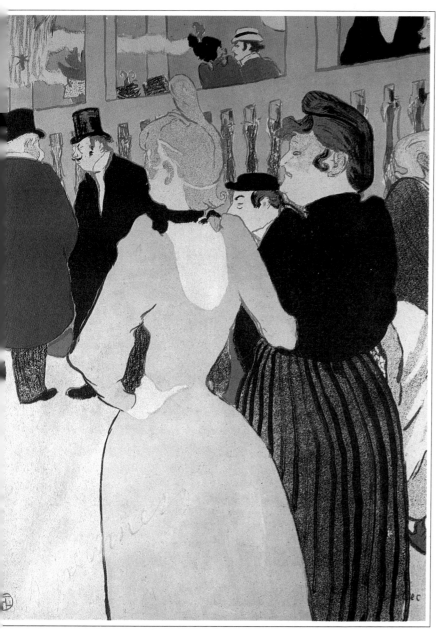

◁ **La Goulue and her Sister at the Moulin Rouge** 1892

Lithograph

THIS IS ANOTHER IMAGE of the top-knotted dancer La Goulue, less frenzied than in her celebrated poster appearance (page 27). Here she is strolling about the dance-floor of the Moulin Rouge with her sister and fellow-dancer Jeanne, nicknamed *La Môme Fromage* (Cheese Girl); if Lautrec's reporting is accurate, the Môme has already lost her figure, while La Goulue is still – though not for long – delightfully wasp-waisted. The picture is a lithograph – that is, Lautrec executed it in the medium he had used for his posters. In fact, this is one of the earliest of the lithographs he made as works of art, to be looked at in an album, or in a frame on the wall, rather than glimpsed on the street. So, although the bold design and large areas of flat colour are typical of Lautrec's poster style, he has drawn in more detail, especially on the background figures.

▷ **Reine de Joie** 1892

Poster

A SUPERB POSTER which must have done wonders for the sales of Victor Joze's now forgotten novel *Reine de Joie* (Queen of Joy). Sensibly enough, a version of Lautrec's design was also used for the title-page. The story's sub-title was 'manners of the *demi-monde*' – that is, the glamorous, gamy world of kept women and their elderly lovers. Lautrec captures the essence of the *demi-monde*, showing a scene in which the heroine turns her charms on a wealthy banker. The contrast between her youthful beauty and the man's grossness is, of course, intentional. The colours Lautrec uses are interesting and effective, notably the banker's olive-green hair trailed across his bald pate, and the red dress and the red-outlined arm of the girl – literally a scarlet woman. The diagonal dividing and enlivening the scene was a favourite device of Lautrec's, often employed on his posters.

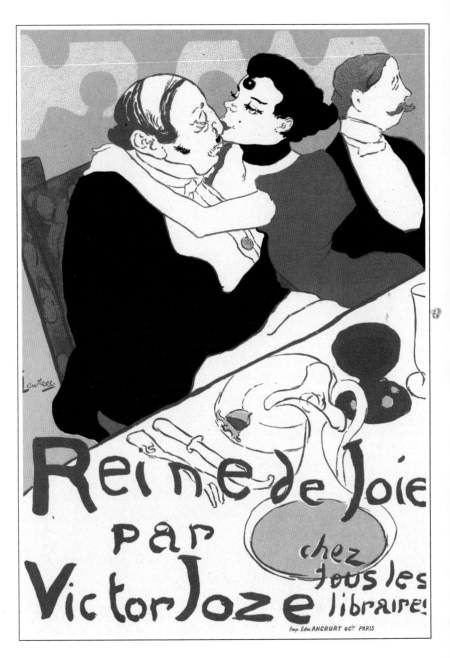

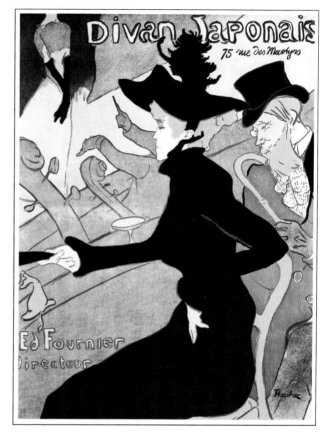

▷ **Divan Japonais**  1892-3

Poster

THE BRILLIANT SUCCESS of this poster consolidated the reputation of Lautrec as the man who had 'conquered the streets of Paris'. The Divan Japonais was a cabaret in the rue des Martyrs where the decor and waitresses' costumes were mock-oriental. *Japonaiserie* had a wide influence in late 19th-century France, not least on artists. Edgar Degas adopted the highly effective Japanese device of cropping figures and objects at the edges of his compositions, giving them an 'accidental', photograph-like immediacy. Lautrec followed suit, and also adopted the bold outlines and large areas of flat, strong colour characteristic of Japanese prints – techniques ideally suited to the attention-grabbing art of the poster. Here the central figures are members of the audience: Lautrec's friend Jane Avril and the critic Edouard Dujardin. The headless performer is Yvette Guilbert (page 45), easily identified by her long neck and long black gloves. The composition is full of curves in art nouveau style, including the necks of the musical instruments, rearing up as full of life as the conductor's arms.

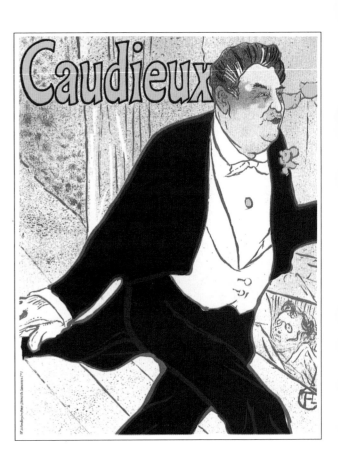

▷ **Caudieux** 1893

Poster

CAUDIEUX WAS A COMEDIAN and singer in the café-concerts of Paris. Lautrec's poster, advertising Caudieux's appearance at the Petit Casino, tells us a good deal about his style as a performer. It suggests the flying coat-tails and rapid strut of the confident professional, about to tell the audience 'Here we are again, folks!' and launch into his patter. He is made to seem larger than life, so much so that he cannot squeeze his entire bulk into the picture space. But typically, Lautrec makes no attempt to glamorize Caudieux: the crude makeup fails to mask the puffy, sagging features of the overweight middle-aged man, driving himself hard to keep on producing an effect of youthful vitality. Caudieux evidently interested Lautrec, who also painted the comedian backstage, as a portly figure in undress, making up in readiness for the night's work.

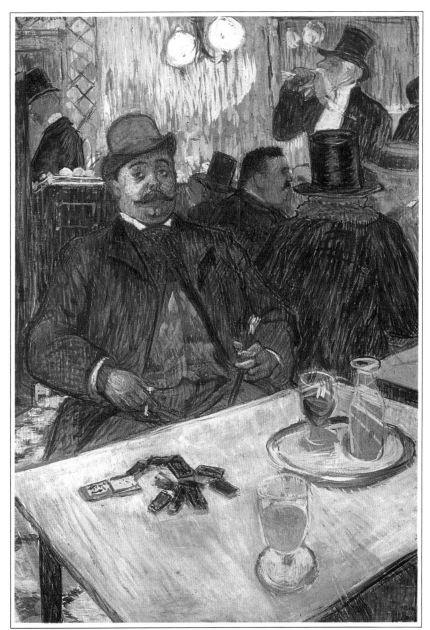

◁ **Monsieur Boileau in a Café** 1893

Paint on cardboard

NINETEENTH-CENTURY French painters were fond of scenes that might well have been labelled 'The Drinker', serving as illustrations for a text on the evils of alcohol. Edgar Degas's painting *Absinthe* is the most celebrated and telling example. If this is Lautrec's contribution to the genre, it is fairly mild, characteristically making no judgements. Moreover, the picture is dedicated (in the top left-hand corner) 'to my friend Boileau' and was presumably not intended to give offence. Still, there is an undeniably alcoholic tinge to the scene, with Boileau at its heart, leaning back in his chair and looking out on the world with the glazed fish-eye of the boozer. And the glass in front of him is filled with absinthe, a drink celebrated in literature, but so brain-destructive that it was eventually banned.

▷ **Monsieur Praince** 1893

Paint on cardboard

THIS IS ONE OF LAUTREC'S most economical studies of the music-hall performer in action, with just the face lit from below to identify Praince's profession and a hasty line to indicate the presence of the stage. Unfortunately, the available information about Monsieur Praince is equally economical: he lives on only in Lautrec's brilliant oil sketch, fixed for ever in the attitude of the artiste giving his all at the climactic moment of a song or story. Praince's portly knees-bend and loud clothes suggest that he was a comedian. Lautrec makes no attempt to characterize him: for the moment, the man is completely submerged in the performer. It has been plausibly suggested that 'Praince' was just the French pronunciation of 'Prince', and that he was one of the many British performers who enjoyed a Parisian vogue in the 90s.

▷ **The Card Players**  1893

Paint on cardboard

THESE TWO GIRLS in their shifts might be sisters or friends, having a game of cards before bedtime. They are in fact prostitutes in a brothel, dressed in their working clothes and passing the time until the clients start to arrive. Lautrec was not the only 19th-century French artist to take his subjects from the brothel, but he was certainly the first to move in for long periods, becoming such a familiar and accepted figure that the girls behaved naturally in front of him: this is what gives his brothel pictures their distinctive quality. Lautrec almost always portrays the girls in off-duty moments, in distinctly un-erotic situations; even the lesbian relationships which seem to have been quite common carry little in the way of a sexual charge. Lautrec records moments from the lives of working girls, either waiting in boredom for employment or thoroughly weary after it.

▷ **Loïe Fuller**  1893

Paint on cardboard

THE CHICAGO-BORN ACTRESS and dancer Loïe Fuller was one of the true originals of her time. Her debut at the Folies-Bergère (October 1892) made an immense sensation, not so much because of the quality of her dancing as the brilliant manipulation of stage illusion. She wore long, full costumes of light-reflective shot silk, which she whirled about with the help of concealed sticks; meanwhile revolving, different-coloured spotlights passed across her figure, so that the combination of swirling, fluent movement and shifting, sparkling colour-patterns created a dazzling impression. It was all the more dazzling because nothing of the kind had ever been seen before (electric lighting had only just been installed at the Folies), though a host of imitators soon sprang up. Lautrec tried to capture Fuller in this painting and in a set of lithographs which he sprinkled with gold dust so that they would reflect the light like the dancer's flowing silks.

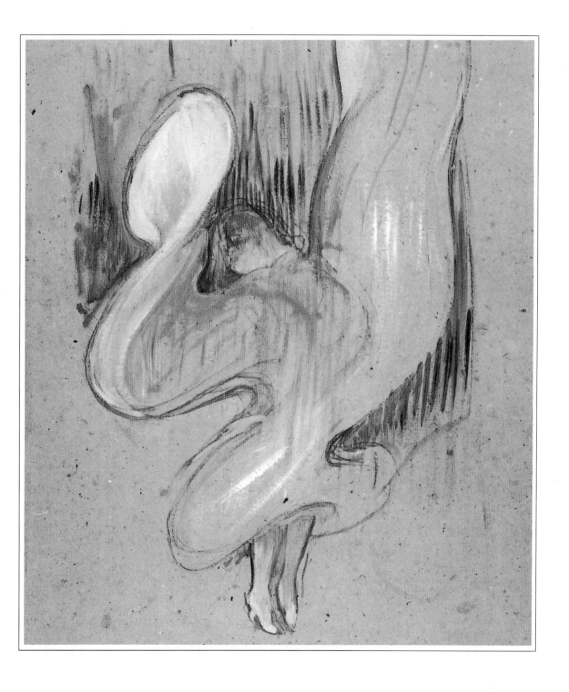

▷ **Women in
the Dining-room** 1895

Oil on cardboard

WOMEN IN A BROTHEL – or
working girls in their dining-
room after a meal? They could
just as easily be a family, albeit
in rather subdued spirits. The
importance of the brothel in
Lautrec's work has, arguably,
very little to do with sex:
customers are almost entirely
absent from his pictures of this
milieu, and if some of the
camaraderie between the girls
has an erotic basis, Lautrec
scarcely insists upon the fact.
But the brothel did provide
him with a kind of extended
family which he could observe
at his leisure, not unkindly but
certainly unsentimentally. This
picture is interestingly divided
along the diagonal of the table
edge, between (left) bright and
(right) relatively dark tones,
and between the lighter mood
created by the only face visible
in the mirror and the less
happy expressions of the
women we can see around the
table.

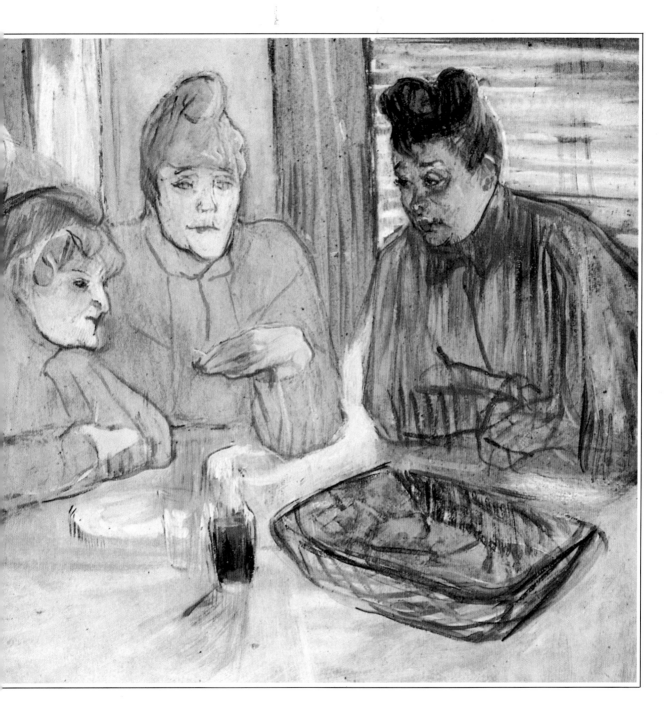

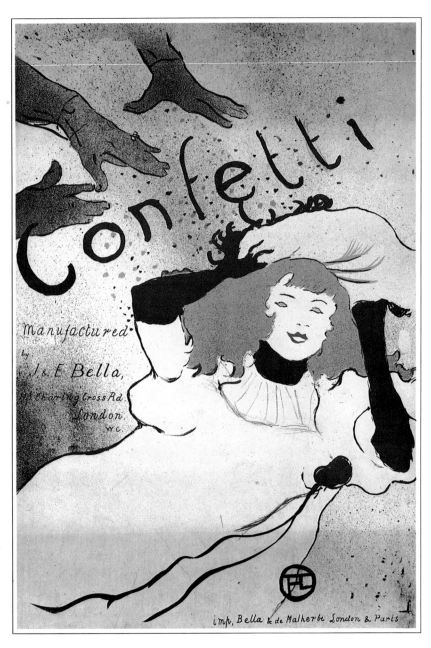

◁ **Confetti** 1894

Poster

AS THE LETTERING on this light-hearted offering indicates, it was designed for an English firm of confetti manufacturers with premises in London's Charing Cross Road. Nevertheless it could easily pass as a spontaneous outburst of gaiety. The girl is said to be a portrait of the popular singer Jeanne Granier. She seems about to take off into space, like a vessel being launched by the shower of confetti thrown by anonymous hands: she is even holding on to her hat as though it might blow away as she floats aloft! In the same year, the firm that commissioned this work invited Lautrec to their poster exhibition at the Royal Aquarium, Westminster. This was one of several visits by the artist to London; but although he shared the contemporary French Anglomania he never stayed long, daunted by the English Sunday and the maudlin gloom of the English drinker.

### ▷ Yvette Guilbert Taking a Curtain Call 1894

Oil on photographic
enlargement of lithograph

OF ALL THE FEMALE performers
Lautrec portrayed, only two
became close friends and
remained so until he died:
Jane Avril (page 32) and the
singer Yvette Guilbert.
Guilbert makes her first
appearance in his work as the
headless performer in *Le
Divan Japonais,* recognizable by
her long neck and the black
gloves that are also prominent
in this painting. Guilbert was
never entirely happy about the
way Lautrec portrayed her:
she wrote to him, 'for heaven's
sake don't make me so terribly
ugly!. . . Not everyone
appreciates only the artistic
side of these things'. Guilbert
had a point, for in her case
Lautrec did exaggerate, always
making her look fascinatingly,
wittily, intelligently – ugly; the
impression is reinforced here
by her theatrical makeup and
the effects of stage lighting.

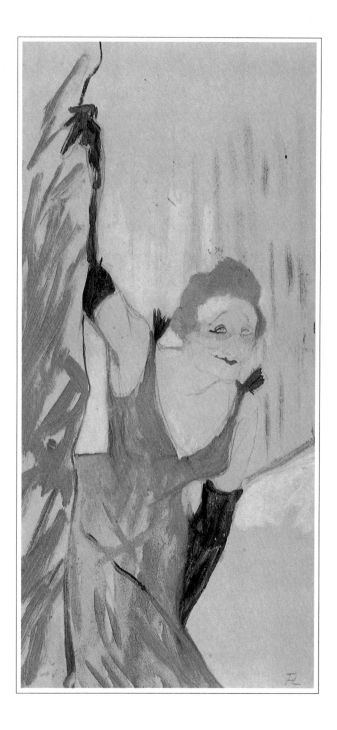

▷ **Babylone d'Allemagne** 1894

Lithograph

*Babylone d'Allemagne* (German Babylon) was a novel by Victor Joze, whose work Lautrec had already publicized to great effect in 1892 (*Reine de Joie,* page 34). Joze was a writer of Polish origin (his real name was Victor Dobrsky) who specialized in sensational stories. Baron de Rothschild believed, with some reason, that he was caricatured in *Reine de Joie,* and his minions had torn down many of Lautrec's posters. *Babylone d'Allemagne* was an exposé of 'Berlin manners', and apparently Lautrec's poster made fun of the Germans even more openly – so much so that Joze got cold feet and tried in vain to stop it being displayed. This was curious, since anti-German feeling had been strong in France ever since her defeat by Prussia in 1870. The poster certainly sends up the pomp and stiffness of the German soldier, while the glad-eye of the lady looking at the mounted officer implies the possibility of less buttoned-up pleasures. This is the lithographic version of the scene, without the lettering.

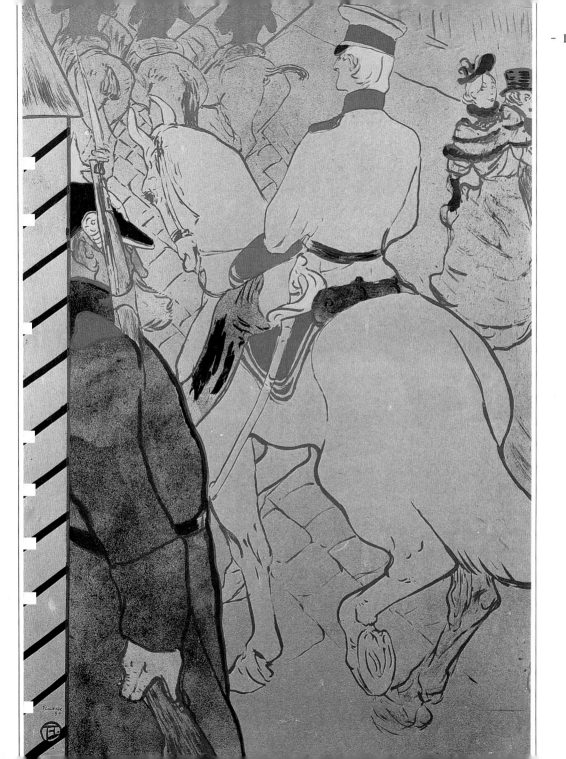

▷ **The Salon in the Rue des Moulins** 1894

Charcoal and oil on canvas

THIS IS THE LARGEST and most ambitious of the fifty brothel paintings done by Lautrec in the early 1890s. His real interest in the subject seems to have begun when he was commissioned to paint a series of decorative panels for an establishment in the rue d'Ambroise. He carried on working there for a time, until he switched to the rue des Moulins, supposedly because one of his favourite girls had moved there. The rue des Moulins was a high-class house that catered for most known erotic idiosyncrasies; Lautrec reveals its pretensions in his rendering of the red velvet furniture and fancy architectural features such as the ribbed columns. But the women, sitting around in various stages of undress, are surprisingly inanimate and unseductive. They have done this kind of work all too often before, and are saving their vivacity – one of their wares – for the clientele.

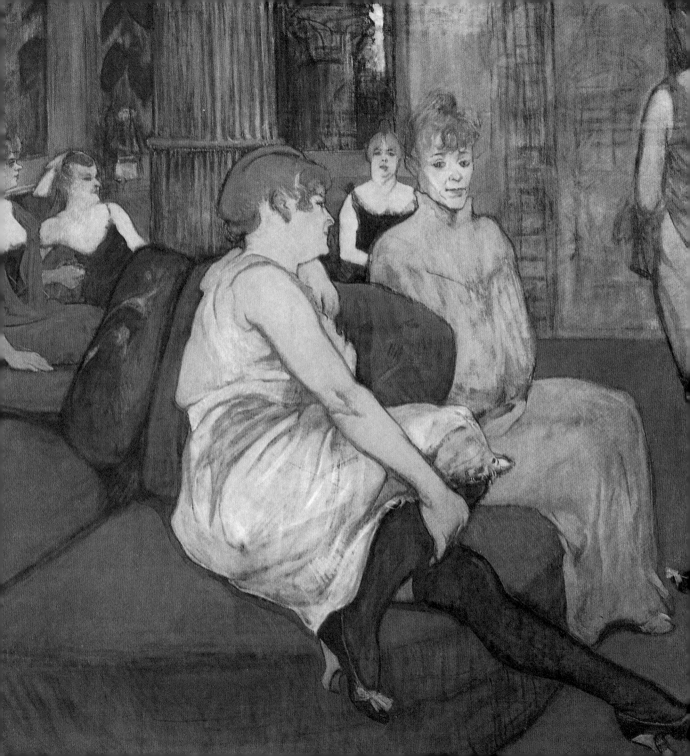

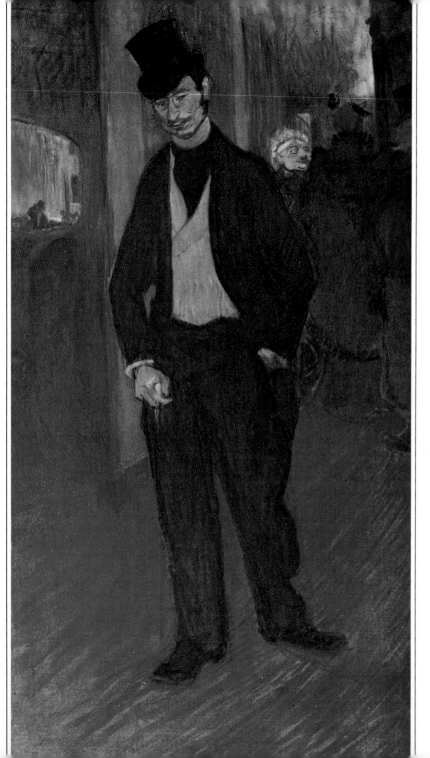

◁ **Portrait of Gabriel Tapié de Céleyran** 1894

Oil on canvas

LAUTREC'S COUSIN, Dr Gabriel Tapié de Céleyran, was his constant companion on alcoholic jaunts through the nightlife of Montmartre. Tall, stooped and rather glum, he presented a contrast to the tiny, excitable Lautrec that the artist often exploited for comic purposes. Tapié seems to have been a long-suffering figure who put up with a good deal of teasing from Lautrec. He also appreciated the importance of his cousin's work, helping to set up the Toulouse-Lautrec collection at Albi twenty years after the painter's death. In this picture Lautrec has created a wholly serious portrait of Tapié – except, perhaps, for the unaccountably grotesque head among the theatregoers at the door of the stalls. Here, at any rate, Tapié is not a butt, or merely glum, but a touchingly pensive, melancholy figure.

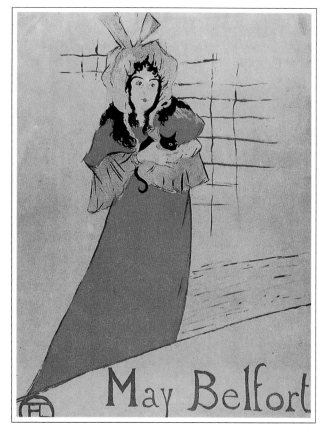

▷ **May Belfort** 1895

Poster

FOR A FEW MONTHS, Lautrec was positively obsessed by the Irish-born singer May Belfort. They were friendly – both were habitués of the Irish and American Bar on the Rue Royale – but Lautrec's interest was primarily artistic; he painted no less than five portraits and made six lithographs of her in 1895, as well as this well-known poster.

May Belfort was the stage name of May Egan, whose career began in 1890 in London. In Paris, at the height of the fashion for English performers, she worked at several popular venues including the Casino de Paris and the Cabaret des Décadents. May Belfort's speciality was a 'little girl' turn in which she dressed in an oversized bonnet and nursery clothes. In her most famous number, 'Daddy wouldn't buy me a bow-wow', she appeared cradling a kitten in her arms. Parisians evidently sensed a hidden erotic appeal in all of this; and her expression is anything but innocent in Lautrec's poster.

## ▷ **May Milton** 1895

Poster

AROUND 1895, performers from across the Channel were all the rage in Paris. Lautrec shared the general enthusiasm, making drawings, paintings and lithographs of all the better-known female performers. As well as May Milton, he portrayed May Belfort, Ida Heath and top-hatted Cissie (translated into French as Cécy) Loftus. May Milton enjoyed a very brief vogue, and very little is known about her. Lautrec's poster, made to advertise a forthcoming American tour, is something of a curiosity. The design is elegant enough, though it is easy not to realize that the girl's right foot – which seems to have lost its shoe – is giving a sideways kick. Her spoilt-child expression and simple frock may be a sly hint to the knowledgeable spectator, for May Milton and May Belfort were intimate friends. In fact Lautrec designed this poster as a twin to the one devoted to May Belfort (page 51), echoing its design and complementing its colour scheme.

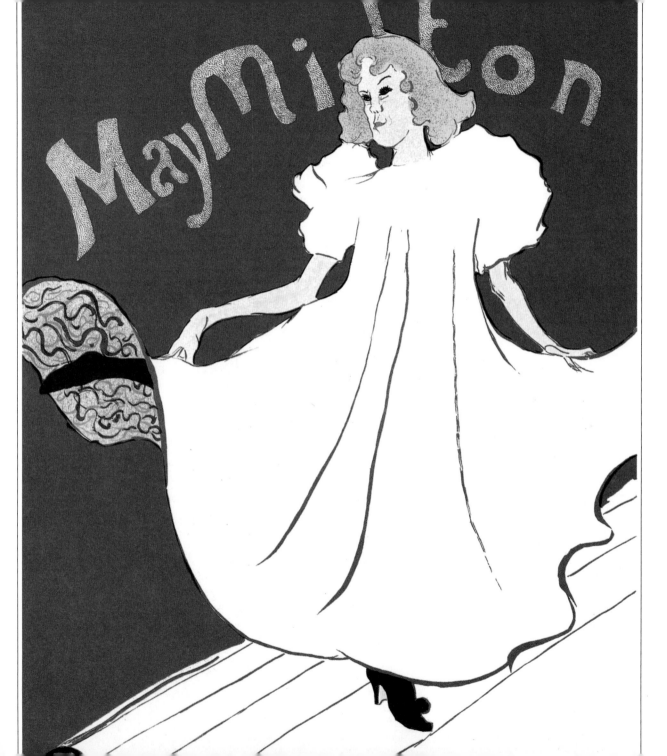

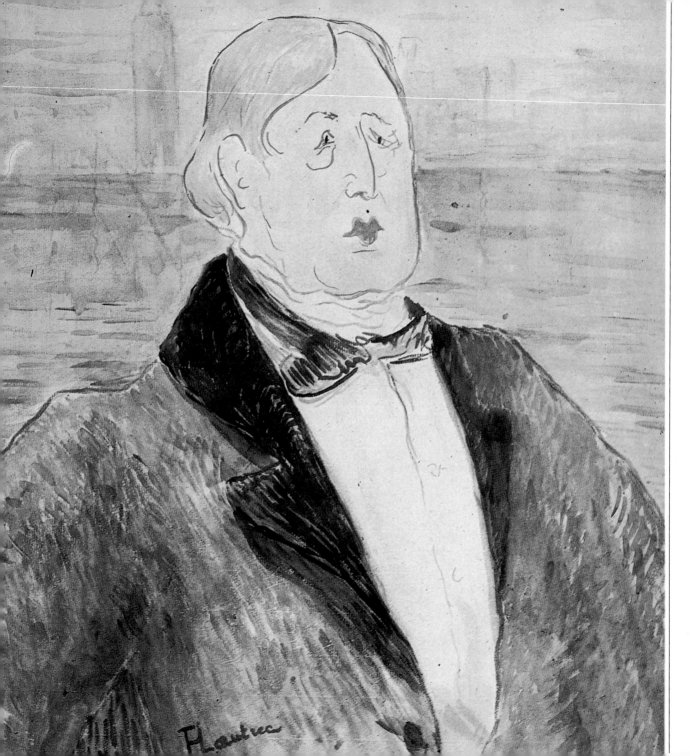

◁ **Portrait of
Oscar Wilde** 1895

Watercolour on cardboard

LAUTREC MET THE IRISH
playwright Oscar Wilde in
highly unusual circumstances.
Wilde was one of the most
famous men of the age, a
wonderful talker who had
distilled his wit into comedies
such as *The Importance of Being
Earnest*. At the height of his
celebrity a libel action
produced evidence that he was
a practising homosexual, at
that time a criminal offence.
Lautrec was in London during
Wilde's subsequent trial, and
was allowed to sketch the
writer for a few minutes. Wilde
was found guilty and
sentenced to three years' penal
servitude. Lautrec's
watercolour makes no attempt
to conceal Wilde's bloated
features and great bulk, but
this is a not unsympathetic
portrait. In France, the
writer's work was not banned,
and the following year Lautrec
used the same image on a
theatre programme for
Wilde's *Salome*.

▷ **La Revue Blanche** 1895

Poster

LAUTREC'S GENIUS as a
chronicler of Montmartre
nightlife makes it easy to forget
that he also moved in other
circles. As a finished
gentleman he was perfectly
capable of mixing with family
friends and relatives, both in
Paris and during the summer
at his mother's country house,
Malromé, in the south-west.
And in the Paris salon of the
exquisite Misia Natanson he
met all the leading writers and
artists of the day, including
Bonnard, Vuillard and Paul
Leclercq (page 68), the
founder of the avant-garde
*Revue Blanche*. This magazine
had been taken over by Misia
Natanson's husband Thadée
and his brother Alexandre,
who asked Lautrec to design a

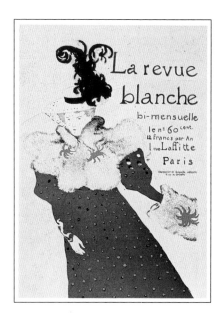

poster for it. The result shows
an engagingly elegant Misia
skating, though the 'cut-off' at
the bottom of the picture
means that the spectator has to
infer the fact from her heavy
furs, her muff, and the angle at
which she is leaning forward.

▷ **Napoleon** 1895

Lithograph

THIS ORIGINATED as a competition entry, which no doubt explains why the treatment is relatively conventional. Early in 1895 the art dealers Boussod and Valadon offered a cash prize and a trip to New York for the best poster design advertising a new life of Napoleon, written by William Millington Sloane and scheduled for publication in the *Century Magazine*. First prize was won by a now forgotten illustrator, Lucien Métivet, who supplied the heroic image of the Emperor that the French judges wanted. Lautrec's submission, a study in oils, was placed a miserable fourth. He nevertheless went ahead and made his own lithograph, printing a hundred copies at his own expense – one of many occasions on which his access to the family funds served the cause of art. In the picture the horses are particularly lively but, appropriately, the brooding presence of Napoleon dominates the composition.

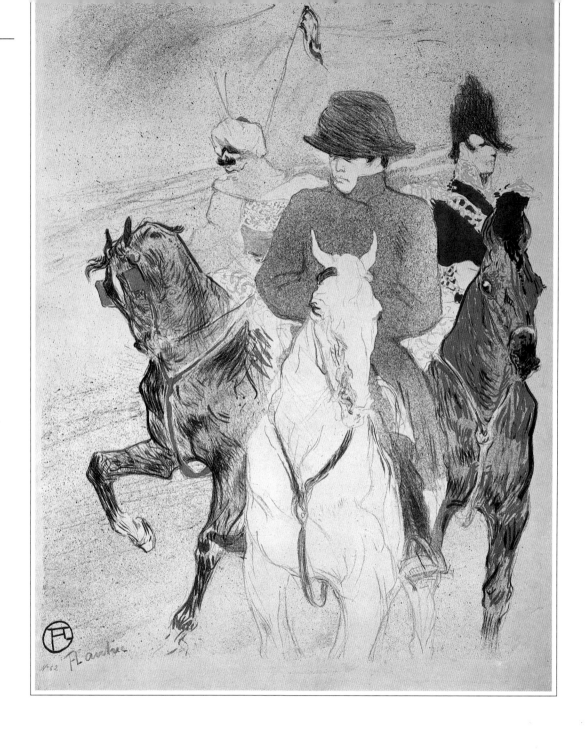

▷ **The Clowness
Cha-U-Kao** 1895

Paint on cardboard

THIS FEMALE CLOWN, dancer
and equestrienne, who called
herself Cha-U-Kao, was the
last performer at the Moulin
Rouge to hold much interest
for Lautrec. He painted her
three times in 1895 and
included a lithograph of her,
*Clowness Seated,* in the series
*Elles* (Those Women). Her
'oriental' name was in fact a
terrible pun: pronounced in
the French fashion it sounded
the same as *chahut chaos*
(can-can chaos). This is one of
Lautrec's most richly painted
and colourful pictures,
apparently showing the
performer getting ready for
her appearance, though the
setting looks more like a
private dining-room than a
dressing room. The brilliant
yellow material is actually a
large collar which she seems to
have worn as her stage trade
mark. The half-seen figure in
evening dress is presumably a
mirror reflection of an elderly
admirer present in the room.

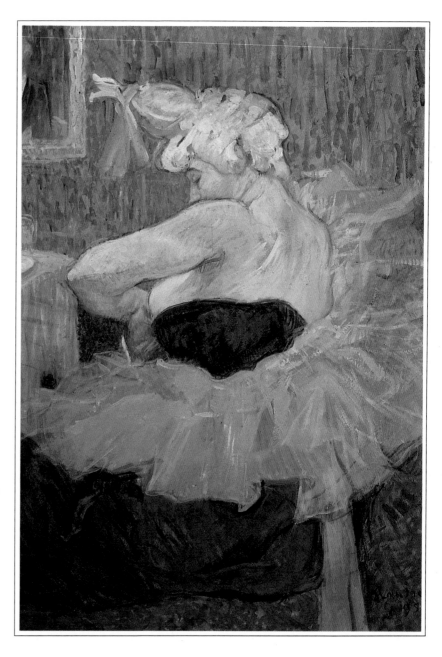

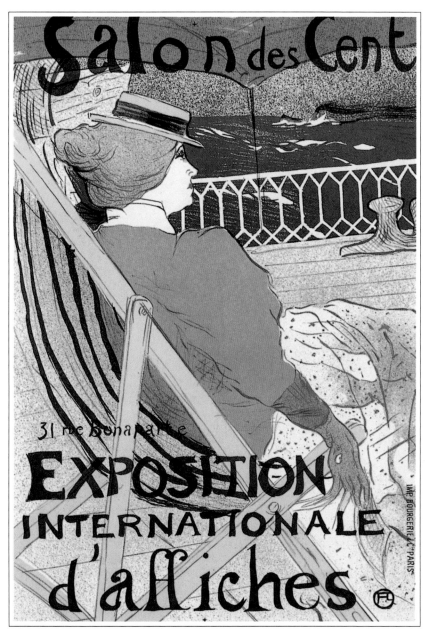

◁ **Salon des Cent**  1895

Poster

THIS IS A POSTER made to advertise posters – an international exhibition of them – held at the Salon des Cent on the rue Bonaparte, Paris. Behind the picture subject lies an odd little story. In the summer of 1895 Lautrec and his friend Maurice Guibert went on a steamer trip, intending only to travel from Le Havre to Bordeaux. But, once on board, Lautrec became enchanted by a beautiful Portuguese woman who sat out in a deckchair every day, reading and dreaming. Lautrec made no attempt to approach her, but insisted on staying on the boat after it reached Bordeaux. Guibert finally persuaded him to leave at Lisbon rather than go all the way to Dakar, where the woman's husband was waiting for her. Lautrec made this elegant lithograph commemorating her as *The Passenger in Cabin 54,* and later adapted it as a poster.

▷ **Dancing at the Moulin Rouge:
La Goulue and Valentin le Désossé** 1895

THIS MOULIN ROUGE SCENE was painted by Lautrec for old time's sake. By 1895 La Goulue (the Glutton) had eaten and drunk so heartily that her star had fallen beneath the horizon. Reduced to taking a booth at a fair and performing pseudo-oriental belly dances, she wrote to Lautrec asking 'if you could find time to paint something for me' to bring in customers. Lautrec responded by executing two large panels which were set up at the entrance to the booth. The one shown here was an evocation of the palmy days when La Goulue was the queen of the *quadrille* (a version of the can-can). The other was a scene of present triumph – wholly imaginary – in which La Goulue's 'oriental' high-kicking was watched by a crowd including Oscar Wilde (page 55), Jane Avril (page 32), the distinguished art critic Félix Fénéon, and Lautrec himself. The triumph never materialized, and La Goulue eventually sank into destitution.

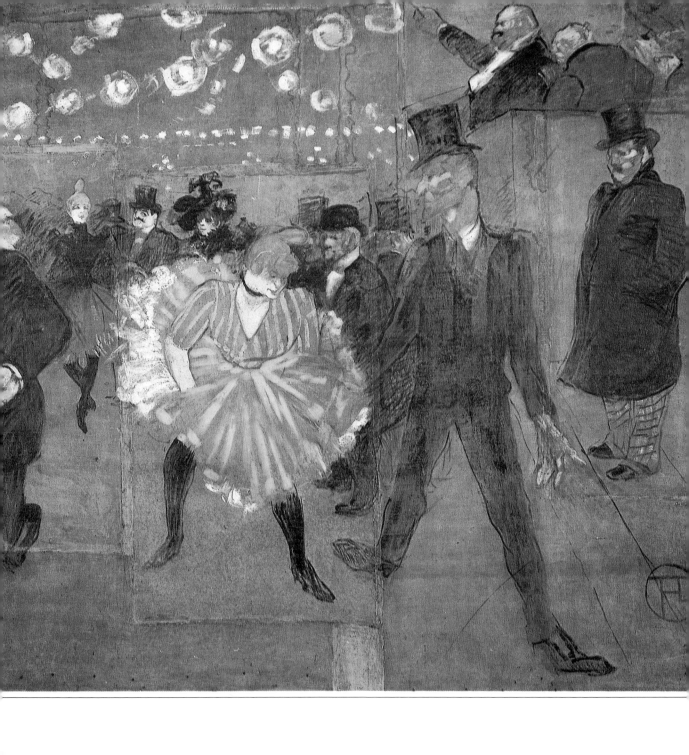

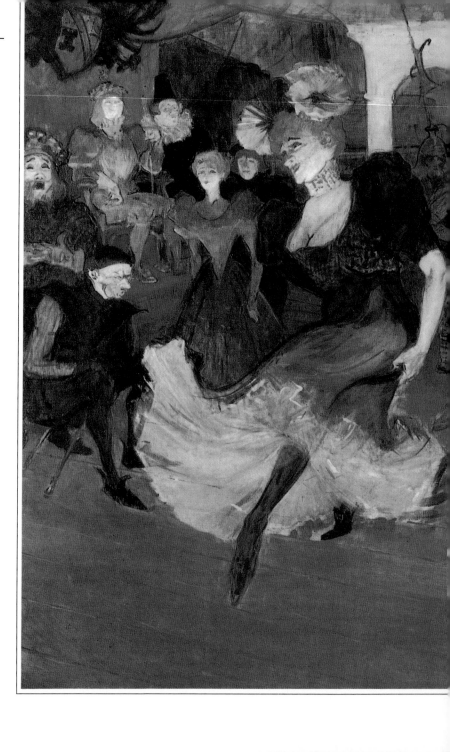

◁ **Marcelle Lender Dancing the Bolero in 'Chilpéric'** 1895

Oil on canvas

IN 1895 PARIS WAS WILD with enthusiasm for *Chilpéric*, an operetta of no great merit with a mock-medieval setting. Its success was all the more surprising because it was a revival. In fact the composer, Hervé, had died three years earlier. Much of the credit belonged to the female lead, the statuesque, red-headed Marcelle Lender. Lautrec had earlier shown a passing interest in her, but now he visited the Théâtre des Variétés every night, timing his arrival to coincide with Lender's performance of the bolero. He had no great ear for music, but told his friends, 'I came to see Lender's back!' As well as making a set of lithographs of Lender, Lautrec painted this large canvas, capturing the absurdity of the scene (medieval costumes, page-girls, a bullfighter and a bolero!) but also the vitality of the performer and the great sense of occasion.

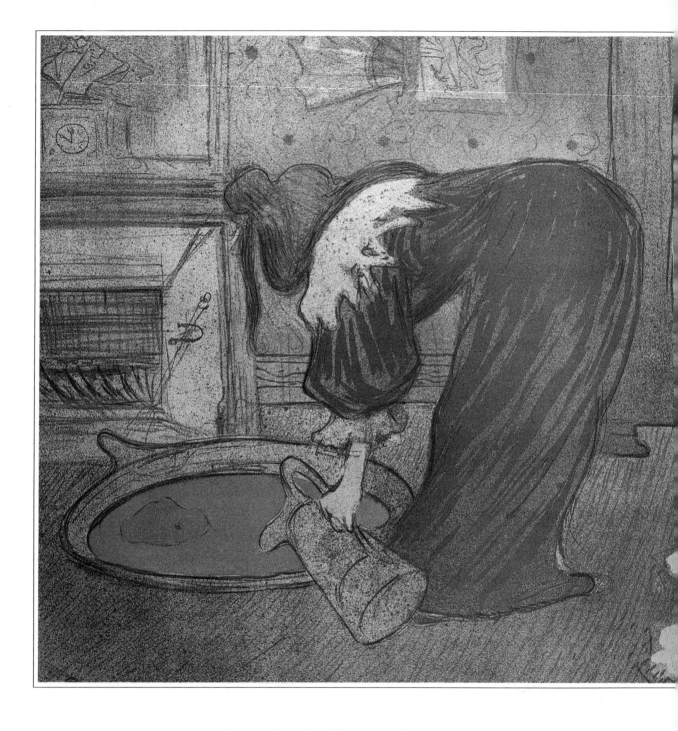

◁ **Woman with a Tub** 1896

Lithograph

IN MANY NINETEENTH-CENTURY French households, the flat tin 'tub' served the same purpose as a modern bidet or shower: the woman poured hot water into it, stood in the middle, and soaped herself down. The artist Degas, whom Lautrec greatly admired and even partly modelled himself upon, made superb nude studies of women in *le tub*. This can be seen as a kind of ironic tribute to the master – ironic because Lautrec's lady is clothed, although she undresses at least as often as Degas's professional models and needs to have more frequent recourse to *le tub*. The bedroom looks respectable enough (apart from a vaguely erotic picture on the wall), but its subject is unmistakable because it is one of a series of lithographs which Lautrec entitled *Elles* (Those Women), devoted to brothel scenes. As usual, however, Lautrec is not interested in glamorizing or judging, but in turning the everyday into art.

▷ **La Chaîne Simpson**  1896

Poster

THE 90S WERE A BOOM period
for cycling in Britain and
France. The invention of the
pneumatic tyre had
transformed the two-wheeler
and the tandem into swift,
comfortable machines,
thrilling to race and liberating
for impecunious young men
and women who wanted to
escape into the countryside.
Lautrec shared the
contemporary enthusiasm
for the sport, although his
infirmities made it impossible
for him to take part. The
poster advertises Simpson's
Lever Chain, and the
Buffalo-Bill-like figure of
Simpson stands in the centre,
hands in pockets, surveying
his handiwork. Next to him,
in the bowler hat and check
suit of the sporting 'character',
stands Louis Bouglé.
Himself a racing cyclist,
Bouglé was also the French
agent for Simpson's, going
under the name of L.B.Spoke
– a terrible English pun,
combining the initials of his
name, the spoke of a wheel,
and the made-to-order
implication of 'bespoke'!
Appropriately, a band plays in
the background.

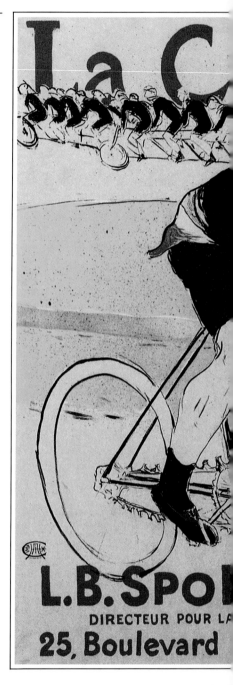

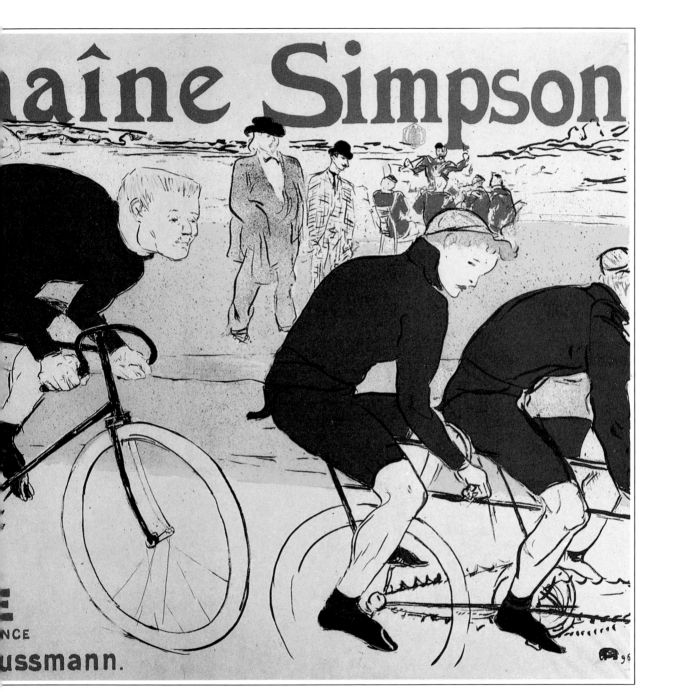

▷ **Portrait of Paul Leclercq** 1897

Paint on cardboard

THE NEATLY DRESSED YOUNG
MAN in the wicker chair is a
young writer named Paul
Leclercq. Lautrec had first met
him in 1894, as one of the
group of writers and artists
associated with his friends the
Natansons and their magazine
*La Revue Blanche* (page 55).
Leclercq had actually founded
the magazine in 1889, and had
been its editor until the
Natansons took it over in
1894. The portrait is in
Lautrec's characteristic style,
though the shape is, for one of
his paintings, unusual. The
sitter engrosses our attention,
but the unobtrusive
background is obviously
Lautrec's studio, with one of
his paintings sketchily
represented on the easel
behind Leclercq's head. In a
published memoir, *Autour de
Toulouse-Lautrec* (1920),
Leclercq claims that the
sittings for his portrait lasted
for no more than two or three
hours; writing over twenty
years later, he may well have
misremembered, for Lautrec
habitually took great pains
over his portraits, of which this
one is an outstanding
example.

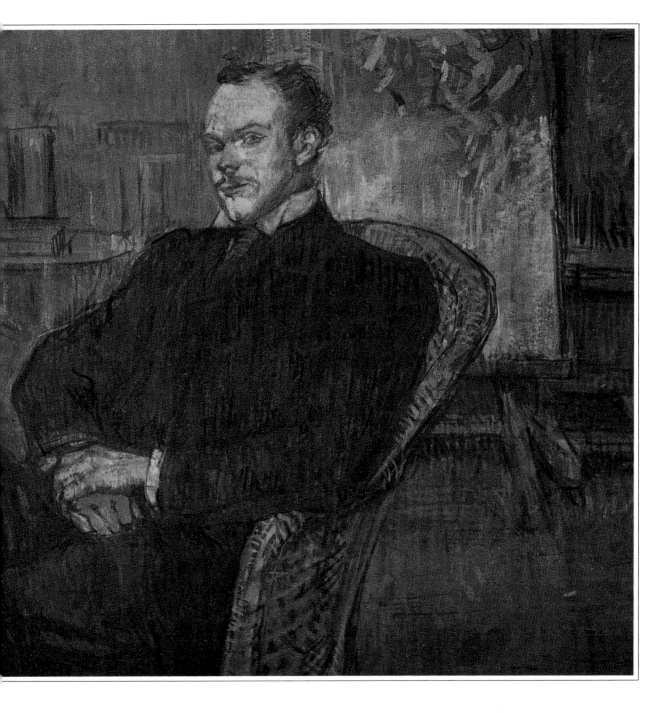

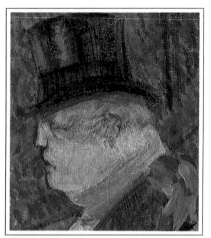

*Detail*

▷ **Study for A Box at the Theatre** 1896-7

Paint and gouache on cardboard

THE CONTRAST BETWEEN the free handling of this picture and the pastel-like effects of *Elsa la Viennoise* (page 72) conveys some idea of Lautrec's artistic resources in his early thirties, just before his health gave way and his output became uneven. For once he is concerned with the audience rather than the performers, and one reason is certainly his obsession with lesbianism. The upright, mannish woman who dominates the picture is Mme Brazier, owner of Le Hanneton, one of the lesbian cafés patronized by Lautrec. She is intent upon the performance, but her pretty friend seems more absorbed in Mme Brazier. Their faces are ghostly under the theatre lights. Two boxes away sits Tom, Baron de Rothschild's coachman, who took Lautrec's fancy and appears in several of his works of this period. The composition of this picture is particularly striking, with the front and side of the box forming a fork holding up the figures, while the partitions isolate their heads.

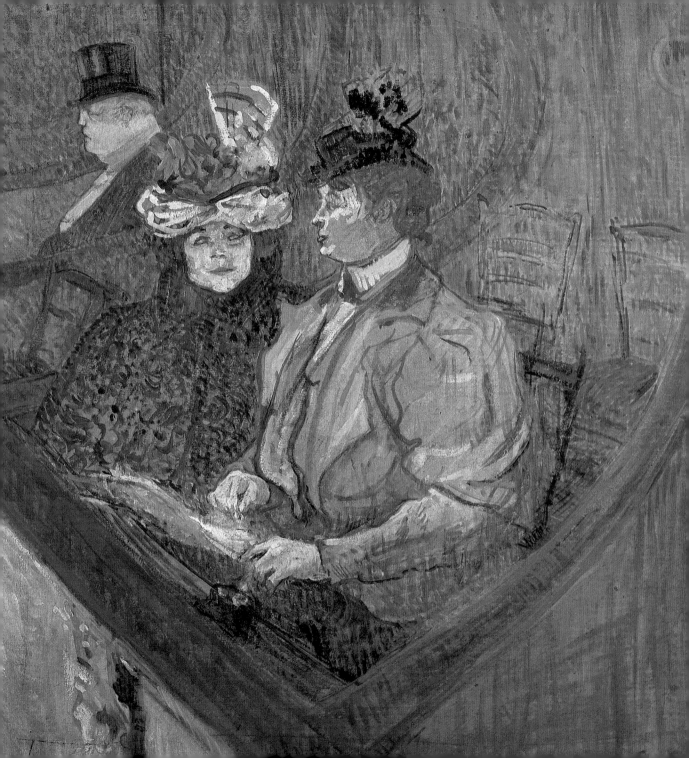

▷ **Elsa la Viennoise** 1897

Lithograph

WE KNOW ELSA only by her nickname, La Viennoise (the Viennese), which may have been a literal description or a comment on her personal style. Since she was on the staff at the Rue des Moulins brothel, whose other inhabitants are shown in a sharply different light on page 48, she certainly appears to have been the odd girl out. Her features are small and refined, her smooth, flattened-down hair is curled at the temples, and she wears a huge, expensive-looking fur cape and a gown covered with sinuous art nouveau patternings. Lautrec enhances the impression she makes by showing her descending a staircase, and by treating the entire picture in a soft style, quite unlike the bold outlines and strong colours used in his earlier lithographs. Whether all this is a private joke, a brothel speciality, or something else again, we are never likely to know.

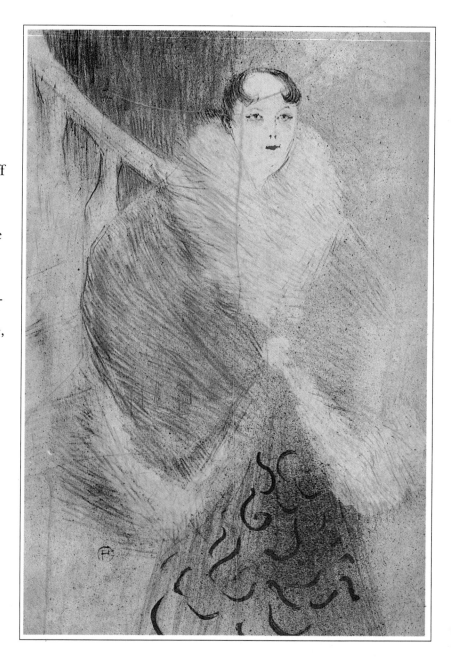

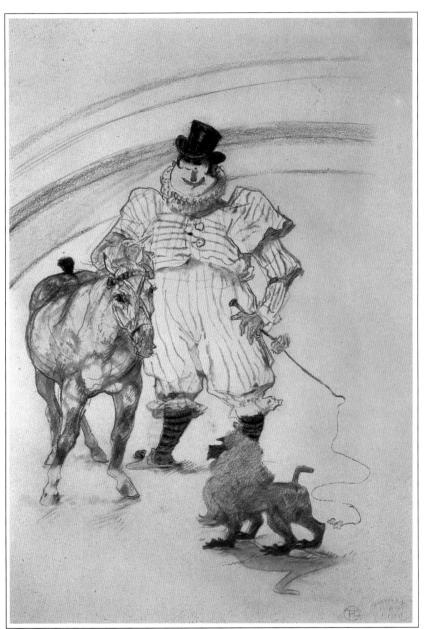

◁ **At the Circus: Clown, Horse and Monkey** 1899

Drawing

LAUTREC'S FIRST LARGE-SCALE painting was *The Cirque Fernando* of 1888, but after this his interest in the circus lapsed. It revived under rather strange circumstances. By 1899 his behaviour was deteriorating fast as a result of his alcoholism, perhaps aggravated by syphilis. In March, after he had had a fit, his mother consented to his confinement in a sanatorium at Neuilly. Lautrec made a rapid recovery and converted his room at the sanatorium into a studio, intent on proving that he was normal and ought to be released. His large output of works in pencil, chalk and crayon included a superb series of circus drawings featuring equestrian feats, a high-wire act, a bear on horseback, a performing elephant and acrobats and clowns. What makes them so very extraordinary is that they were done entirely from memory, yet with astonishing accuracy.

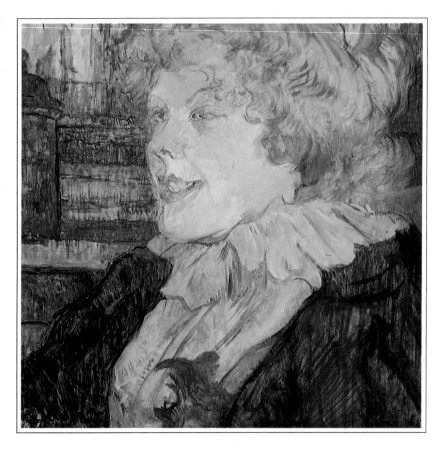

◁ **The Englishwoman at 'The Star'** 1899

Oil on panel

AS PART OF HIS CONVALESCENCE after a bad attack of delirium tremens, Lautrec travelled to Le Havre in order to go on a cruise. With him went his 'minder', a distant cousin named Paul Viaud, whose task was to keep Lautrec away from the bottle. Whether or not he succeeded at Le Havre is unclear, but Lautrec, an admirer of all things English, certainly enjoyed dropping in at The Star, a pub mainly frequented by English sailors. There he fell under the spell of 'Miss Dolly', the pub's English barmaid, and became so enthusiastic that he cabled his friend Maurice Joyant to send his painting gear to Le Havre. He made a fine red chalk drawing of Miss Dolly and this superb portrait. Apparently her charm for Lautrec lay in her abundant health and vitality, qualities which are superbly captured here. The free, light painting style was a new departure for Lautrec.

▷ **The Private Room at the Rat Mort** 1899

Oil on canvas

HAVING EXHAUSTED his enthusiasm for Miss Dolly (page 74), Lautrec left Le Havre for a cruise with Viaud. On his return to Paris he discovered that he had already been written off as dead by the newspapers. . . and that the prices of his works had accordingly risen! He also found his way to haunts old and new, where he started drinking again with a vengeance. Le Rat Mort was a restaurant, much more luxurious than its name (The Dead Rat) suggests. Lautrec's painting conveys a strong sense of plush and gas lighting. The woman was a well-known courtesan, Lucy Jourdan, whose lover is said to have commissioned the picture. Working in a new, richer style, Lautrec captures her showy blonde looks and ample flesh, implicitly as succculent and inviting as the fruits beside her.

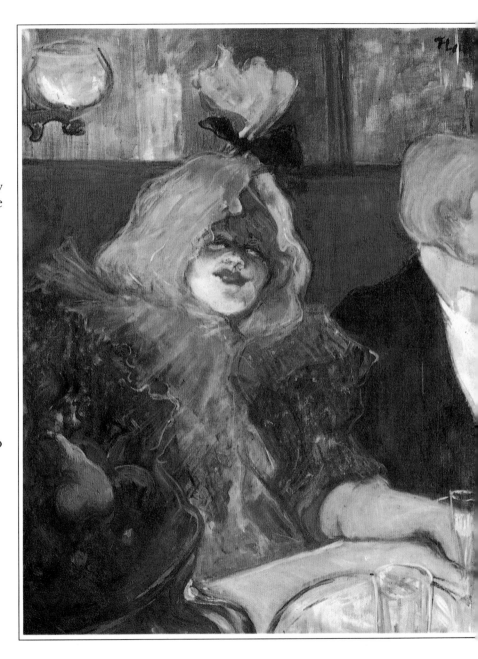

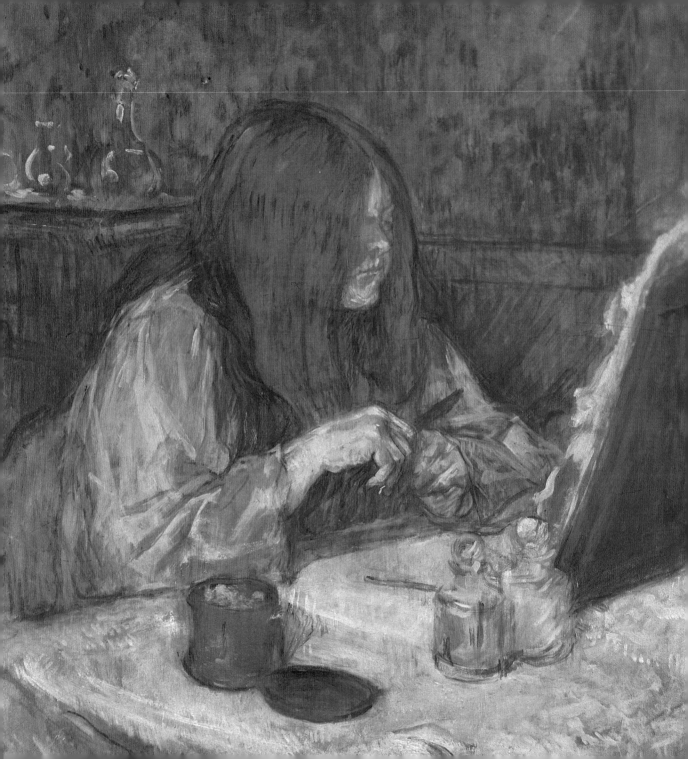

◁ **Mme Poupoule at her Dressing Table** c.1899

Panel

LESS RICHLY PAINTED but probably later than *Private Room at the Rat Mort* (page 75), this is still more densely executed than the works of Lautrec's heyday. Mme Poupoule is yet another of the women whom Lautrec made immortal without preserving anything more than her name and appearance. Though the setting is believed to be a room in a brothel, there is nothing to suggest the girl's trade, except perhaps the quality of her self-absorption. Pausing in the middle of her toilet, with a restricted range of aids on the table in front of her, Mme Poupoule contemplates her reflection in the mirror. Her long hair helps to emphasize that she is shut up in herself, not in the least conscious of the spectator. We will never know whether she is looking into an empty future or realizing that she is losing her looks (or both); but her mood, and that of the picture, is distinctly cheerless.

*Detail*

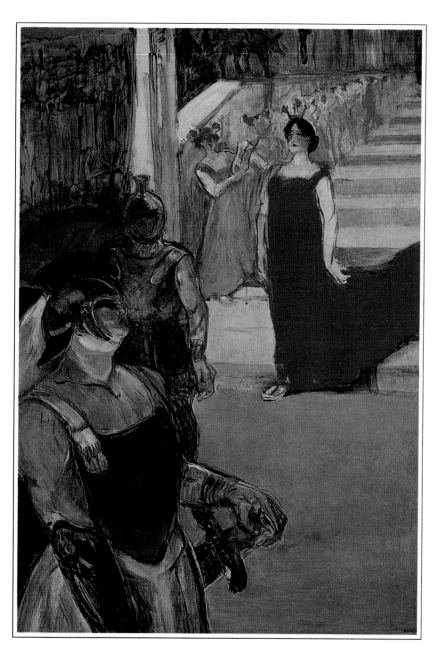

◁ **Messalina Descending the Staircase** 1900-1

Oil on canvas

AFTER HIS BREAKDOWN and incarceration in a sanatorium in 1899, Lautrec spent relatively little time in Paris, although he was drinking again and his health was deteriorating. In the summer of 1900 he established himself in Bordeaux, where he saw *Messalina,* an opera by the British composer Isidore de Lara. Lautrec was less interested in the subject or in the music, than in the prima donna, Mlle Ganne, whose 'burning look' excited him greatly. Working with the help of photographs, he completed a series of six Messalina paintings in the winter of 1900-1, of which *Messalina Descending the Staircase* is generally considered the best. This was Lautrec's last significant effort as an artist. He had a paralytic attack in December 1900; after a second attack in August 1901 he was taken to his mother's house, Malromé, to die.

## ◁ **Mme Poupoule at her Dressing Table**  c.1899

Panel

LESS RICHLY PAINTED but probably later than *Private Room at the Rat Mort* (page 75), this is still more densely executed than the works of Lautrec's heyday. Mme Poupoule is yet another of the women whom Lautrec made immortal without preserving anything more than her name and appearance. Though the setting is believed to be a room in a brothel, there is nothing to suggest the girl's trade, except perhaps the quality of her self-absorption. Pausing in the middle of her toilet, with a restricted range of aids on the table in front of her, Mme Poupoule contemplates her reflection in the mirror. Her long hair helps to emphasize that she is shut up in herself, not in the least conscious of the spectator. We will never know whether she is looking into an empty future or realizing that she is losing her looks (or both); but her mood, and that of the picture, is distinctly cheerless.

*Detail*

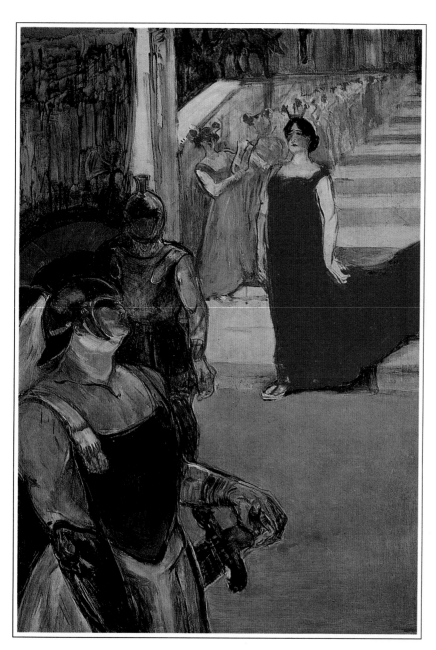

◁ **Messalina Descending the Staircase** 1900-1

Oil on canvas

AFTER HIS BREAKDOWN and incarceration in a sanatorium in 1899, Lautrec spent relatively little time in Paris, although he was drinking again and his health was deteriorating. In the summer of 1900 he established himself in Bordeaux, where he saw *Messalina,* an opera by the British composer Isidore de Lara. Lautrec was less interested in the subject or in the music, than in the prima donna, Mlle Ganne, whose 'burning look' excited him greatly. Working with the help of photographs, he completed a series of six Messalina paintings in the winter of 1900-1, of which *Messalina Descending the Staircase* is generally considered the best. This was Lautrec's last significant effort as an artist. He had a paralytic attack in December 1900; after a second attack in August 1901 he was taken to his mother's house, Malromé, to die.

## ACKNOWLEDGEMENTS

The Publisher would like to thank the following for their kind permission to reproduce the paintings in this book:

**Bridgeman Art Library, London** /**Christie's, London** 33, 57, 64-65; /**Courtauld Institute Galleries, University of London** 75; /**Giraudon** /**Art Institute of Chicago** 18-19; /**Giraudon** /**Louvre, Paris** 24; /**Giraudon** /**Musée d'Orsay, Paris** 32, 58; /**Giraudon** /**Musée Toulouse Lautrec, Albi** 8, 9, 47; /**Giraudon** /**Musée de la Ville de Paris, Musée du Petit Palais** 10-11; /**Glyptothek, Copenhagen** 15; /**Los Angeles County Museum of Art** 78; /**Louvre, Paris** 20; /**Magyar Nemzeti Galeria, Budapest** 42-43; /**Musée d'Orsay, Paris** 54, 68-69, 72; /**Musée Toulouse Lautrec, Albi** 12, 26, 30, 41, 44, 45, 48-49, 50, 74, 76, 77; /**Museum of Modern Art, Cleveland** 37; /**Narodni Gallery, Prague** 28, 29; /**Philadelphia Museum of Art, Penn. USA** 22-23; /**Private Collection** 16, 17, 34, 36, 38, 39, 51, 55, 66-67, 70, 71, 73; /**Private Collection: Mrs. John Hay Whitney, NY** 62-63; **Tate Gallery, London** 13; /**By Courtesy of the Board of Trustees of the V & A** 31, 35, 53, 59; /**Musée d' Orsay, Paris** 25; /**Louvre, Paris** 61.